a friend indeed

indeed

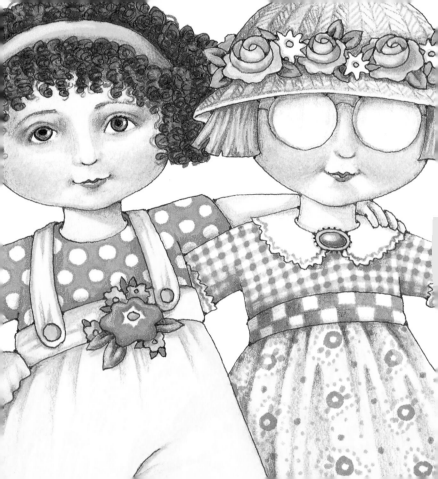

a friend indeed

illustrated by mary engelbreit

written by patrick regan

**Andrews McMeel
Publishing**

Kansas City

www.andrewsmcmeel.com
www.maryengelbreit.com

 and Mary Engelbreit are registered trademarks of
Mary Engelbreit Enterprises, Inc.

02 03 04 05 06 LEO 10 9 8 7 6 5 4 3 2 1

Design by Stephanie R. Farley and Delsie Chambon

ISBN: 0-7407-2904-7

When I have opened
my heart to a
friend,
I am more myself
than ever.

— Thomas Moore

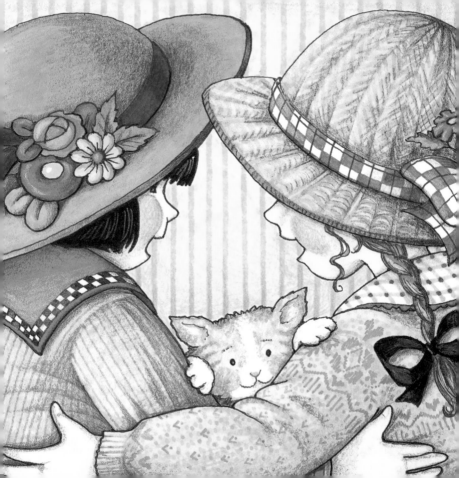

That old line about counting blessings

Is advice we'd all do well to heed—

And whenever I do,
my thoughts
turn to you,

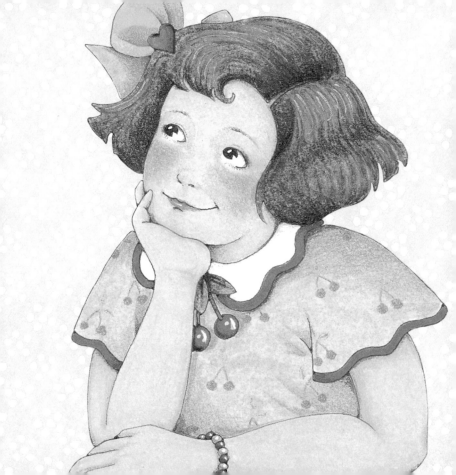

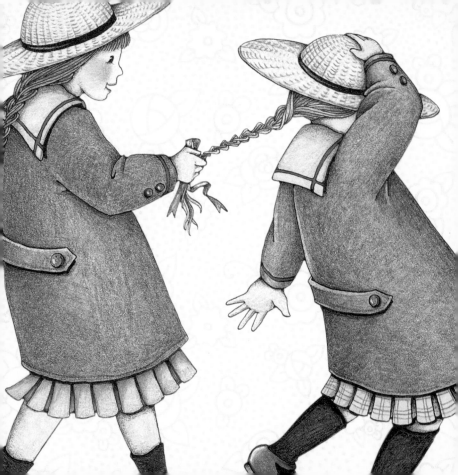

For you are a

 friend

indeed.

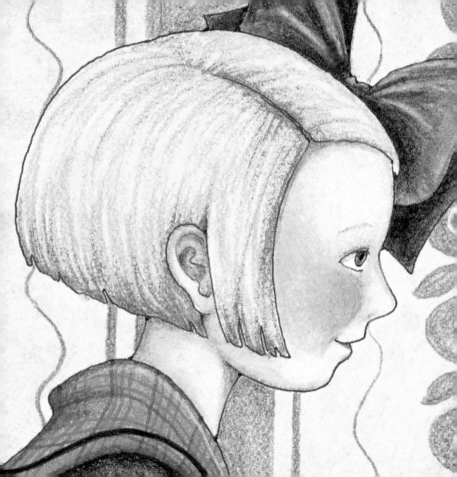

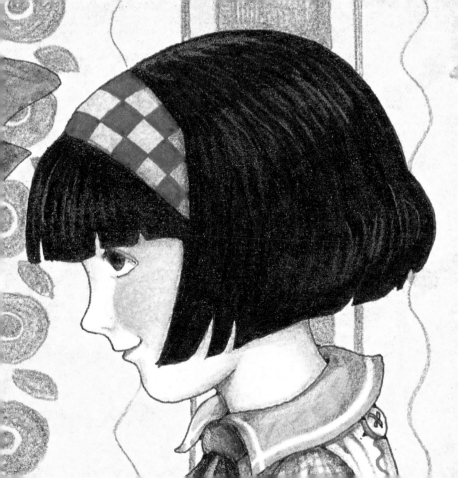

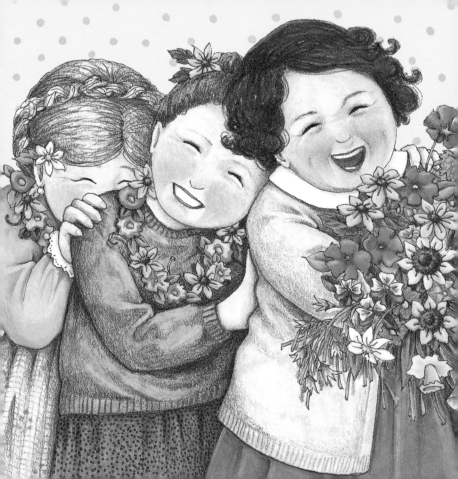

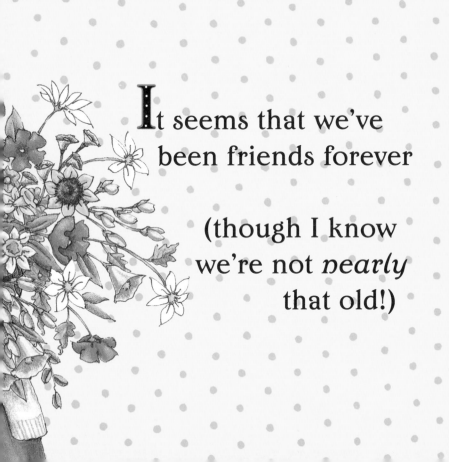

It seems that we've been friends forever

(though I know we're not *nearly* that old!)

But I'll not
take for granted—
I'm still quite
enchanted—

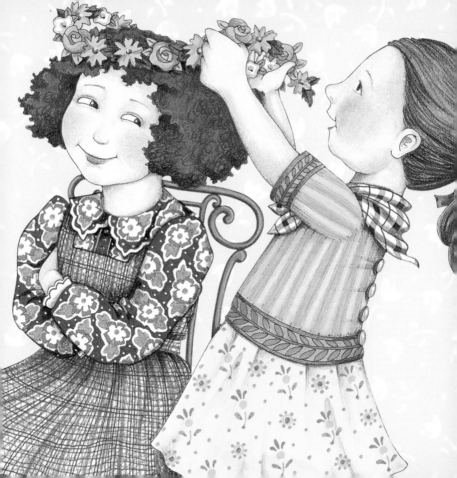

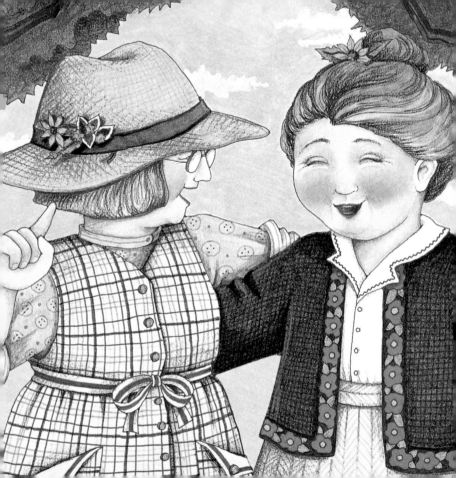

Vintage friends are more
precious than
gold.

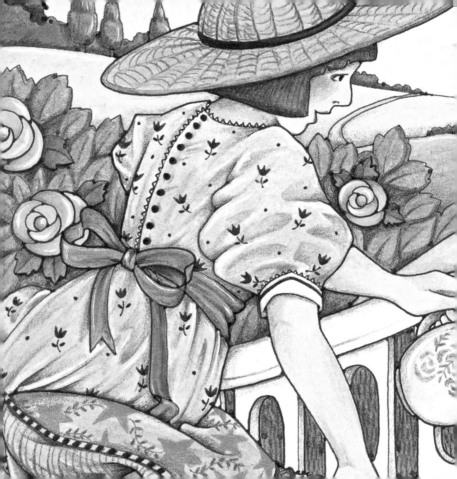

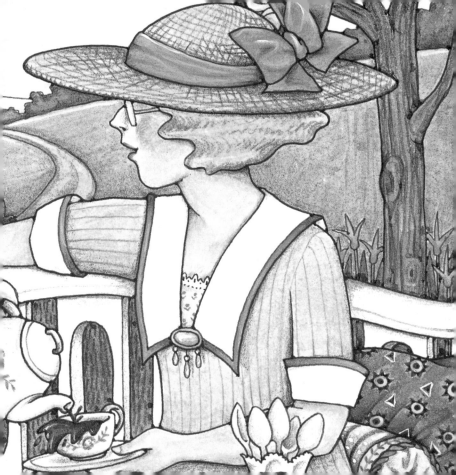

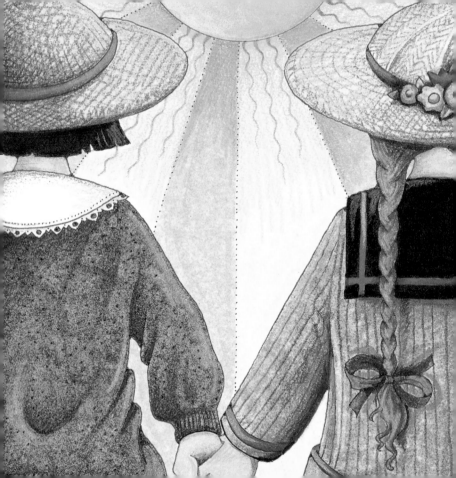

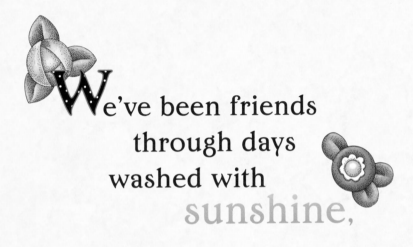

We've been friends
through days
washed with
sunshine,

And through times
when the sky
turned to gray.

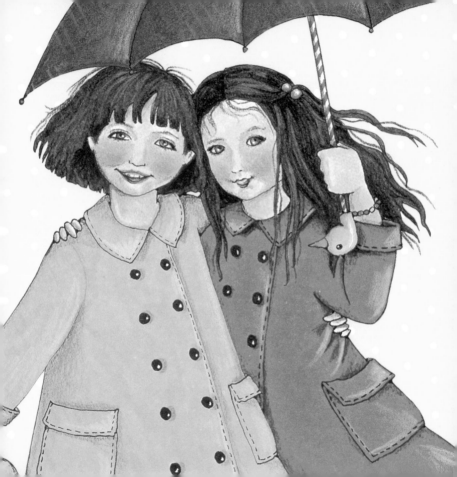

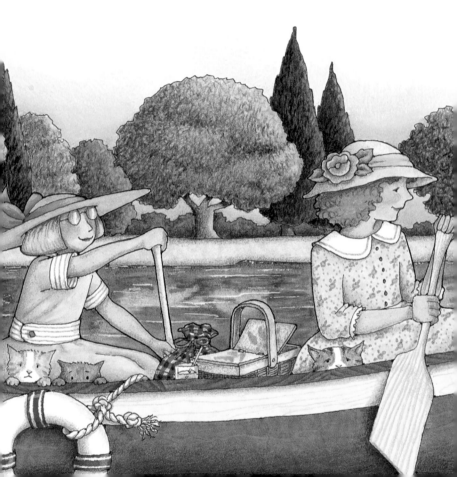

But when storms
rocked
the boat,
friendship
kept us afloat.

Friends indeed make
the tough times okay.

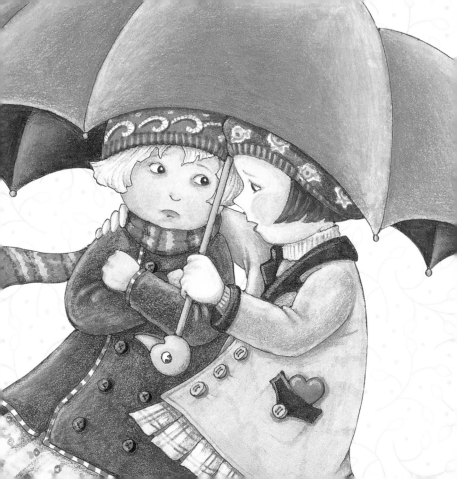

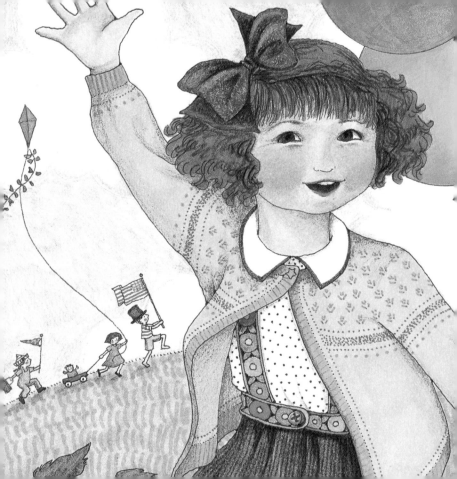

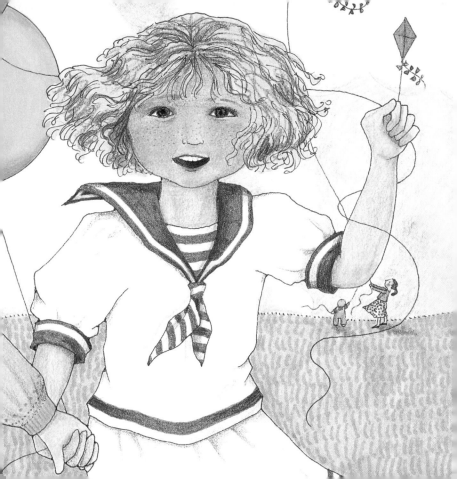

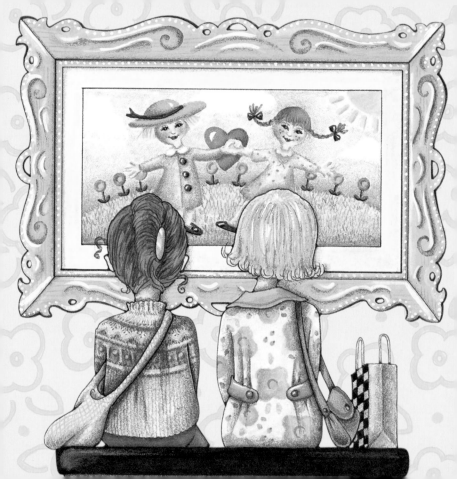

Friends like you help me
keep my perspective

When clear thought
proves illusive to find.

And when worries
unfetter,
two heads make it
better—

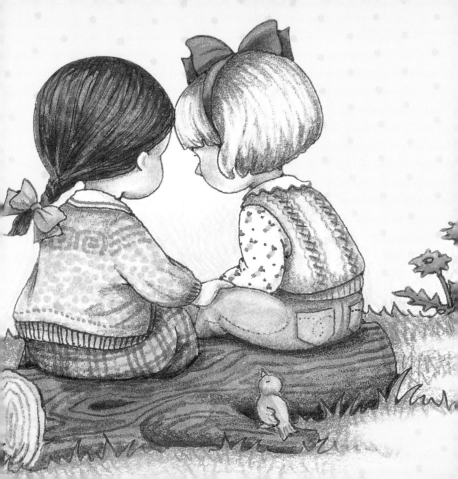

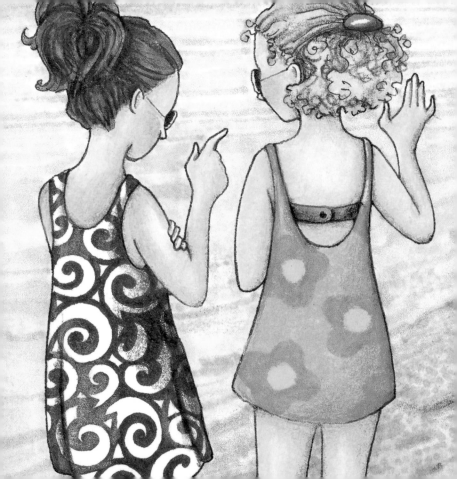

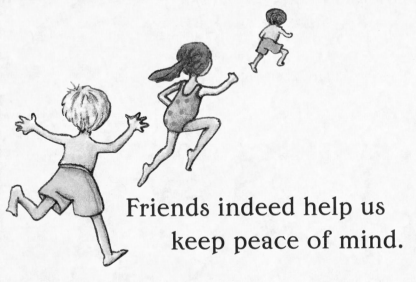

Friends indeed help us
keep peace of mind.

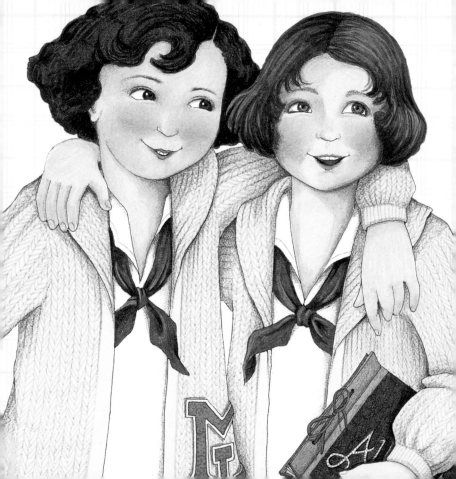

If we stay side-by-side
on life's journey,

We'll enjoy it
wherever it leads—

From now till forever,
we'll stick close together

And we'll always be

friends

indeed.

For Trip.
Best Friend
And Sister
Love
Bonnie